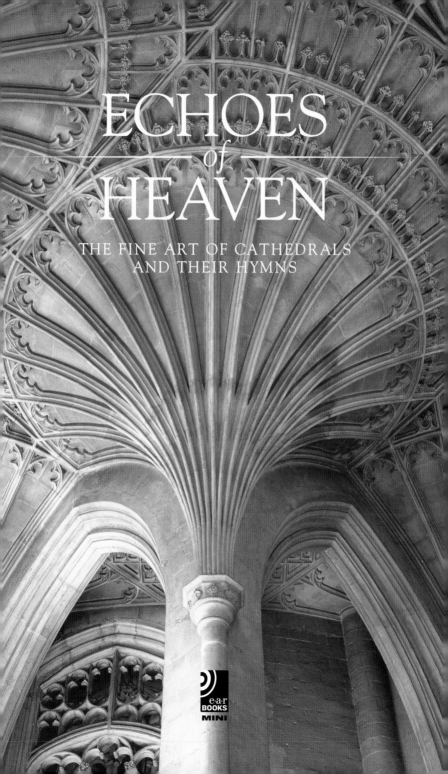

ECHOES
of
HEAVEN

THE FINE ART OF CATHEDRALS
AND THEIR HYMNS

e·ar
BOOKS
MINI

Designed by Guido Scarabottolo and Raffaela Busia
Adapted for earBOOKS mini by Petra Horn

Produced by optimal media production GmbH, Röbel/Germany
Printed and manufactured in Germany

earBOOKS is a division of edel CLASSICS GmbH
For more information about earBOOKS please browse **www.earbooks.net**

 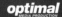

FOREWORD

Cathedrals and churches have shaped the skylines of our towns and cities over the centuries. Towering above all other buildings at the time they were dedicated, they now increasingly take their place in a substantially altered silhouette, challenged for supremacy by larger buildings. Their interiors, however, have retained their unique character and spiritual aura.

When we enter a medieval church, we sense an inexhaustible store of transcendental wealth and few are immune to its spell. Anyone who has stood in Chartres cathedral on a sunny day and observed the play of light from the Gothic stained glass will never be able to forget the experience.

Church naves impress us with their appearance of endless distance and exaltation: radiant, wellnigh weightless spaces, whose walls seem to melt away, built to a mathematical system worked out down to the tiniest detail, based mostly upon just a few "divine" figures and representing structural achievements that today - for all our technical advances - we often strive in vain to emulate.

One source of constant amazement is the artistic diversity and the wealth of detail. Imagination has been given free rein despite all the conditions governing its application. And each little portrayal, however contributory and concealed, was executed with the same care as the most splendid, most monumental display of skill and art. All the more amazing, then, that this rich diversity, expressed in buildings erected over decades if not centuries, should create such a coherent overall impression.

Romanesque and Gothic churches are some of the greatest achievements I know in the architecture of the Occident. Over the past 15 years I have photographed hundreds of churches. Seeing them, considering their nature and capturing their images form three parts of an integral whole for me.

I hope I can convey some of this to those who hear the music and look at the pictures in this book.

Florian Monheim

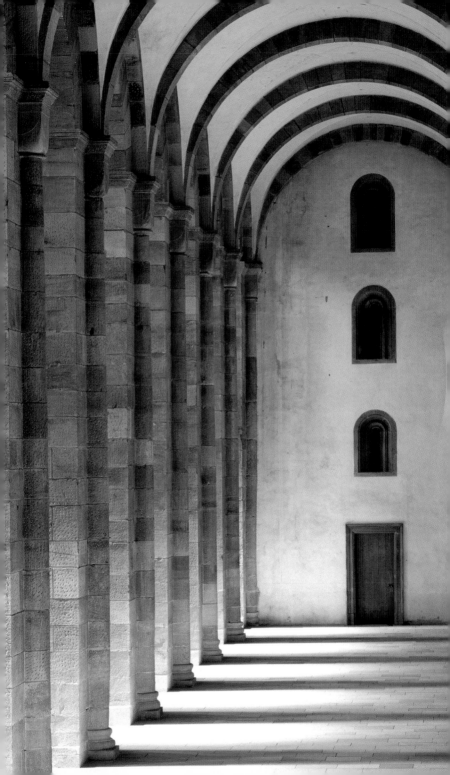

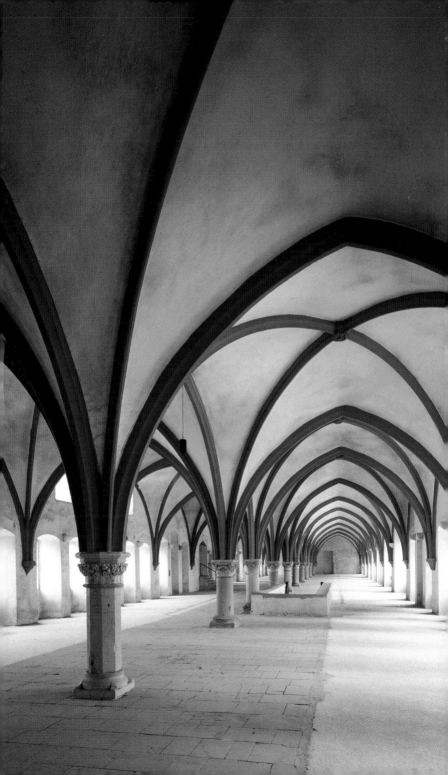

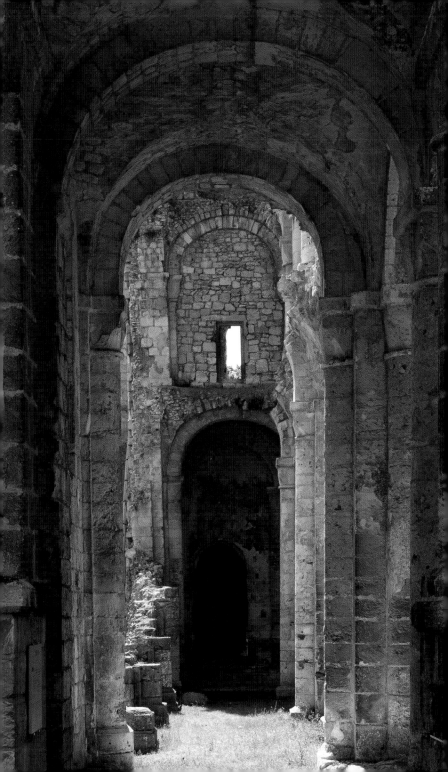

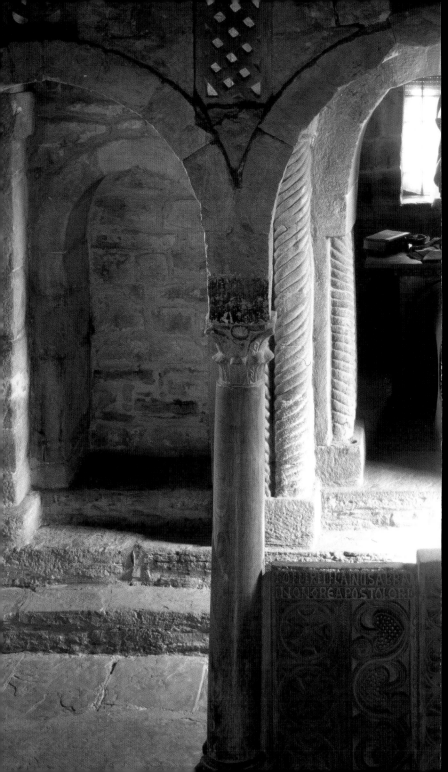

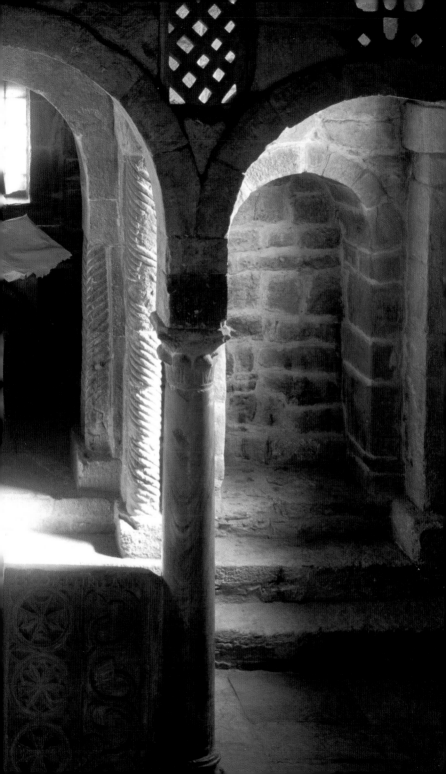

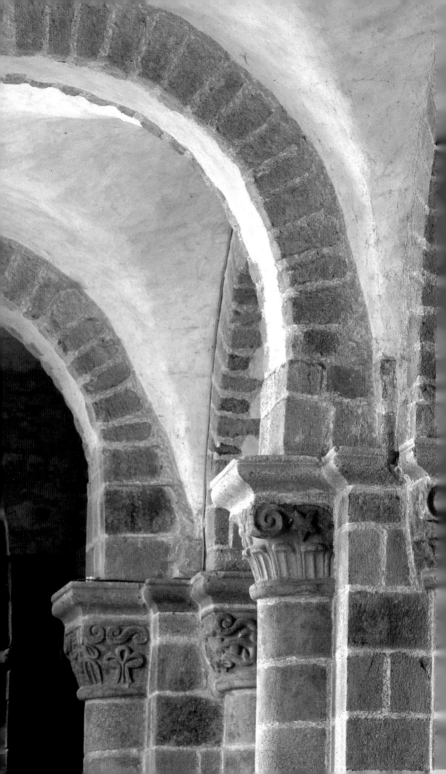

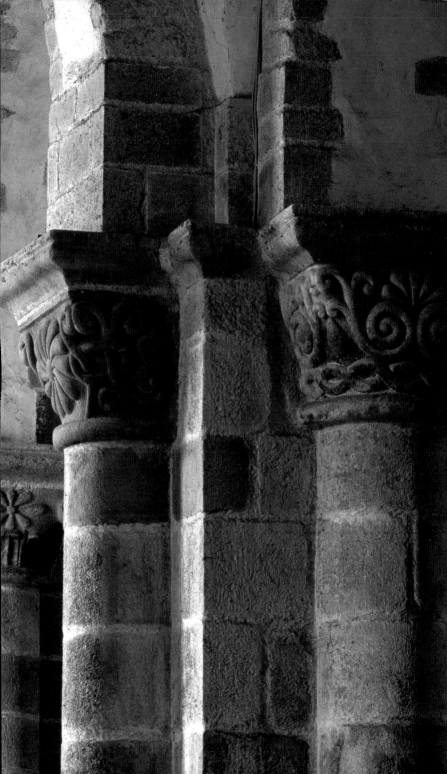

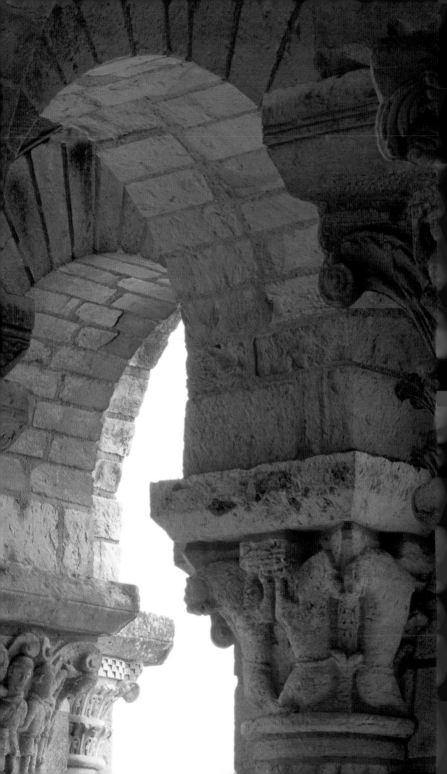

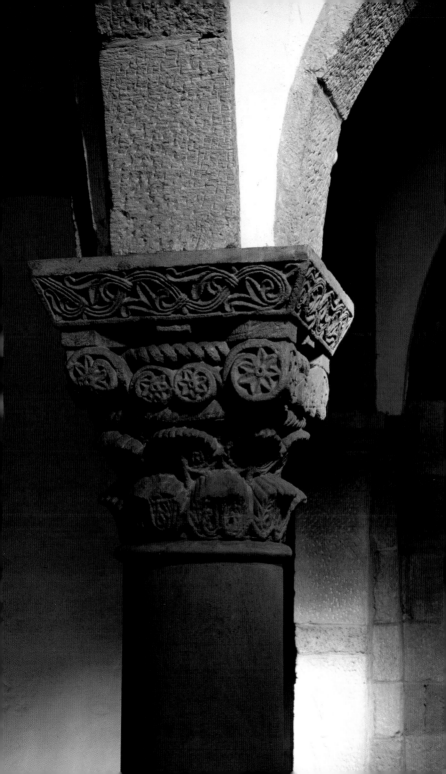

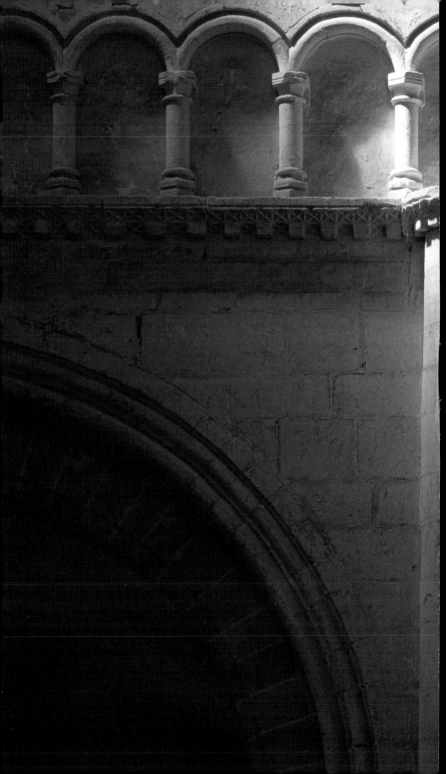

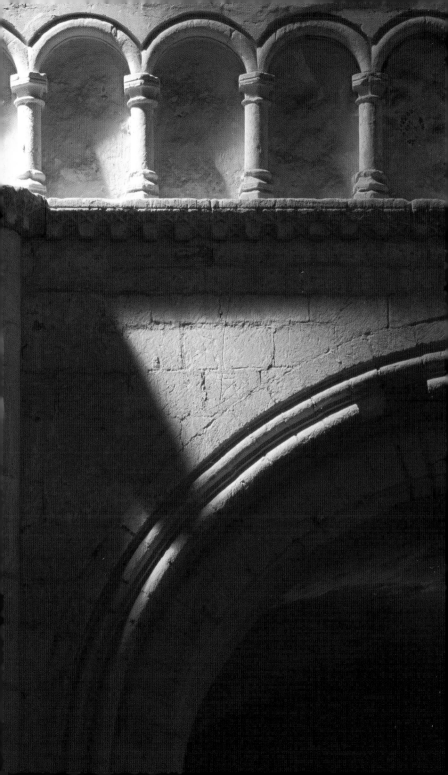

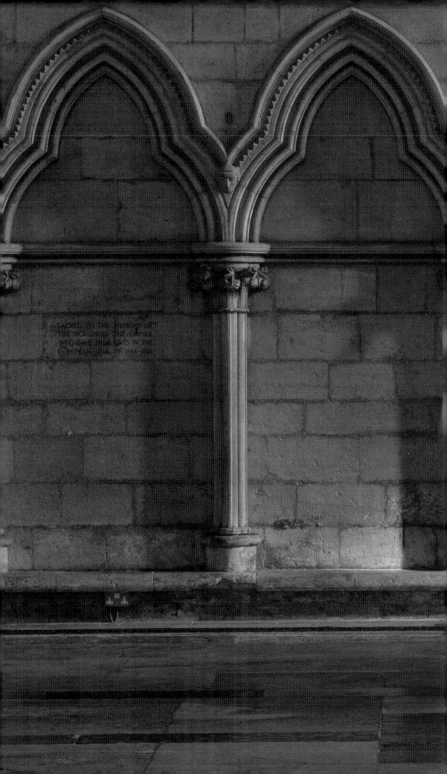

SACRED TO THE MEMORY OF
THE WONDER OF THE EMPIRE
WHO GAVE THEIR LIVES IN THE
EUROPEAN WAR OF 1914-1918

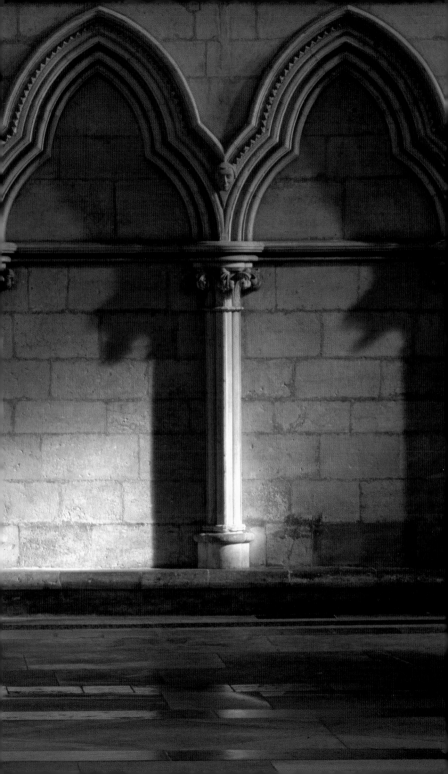

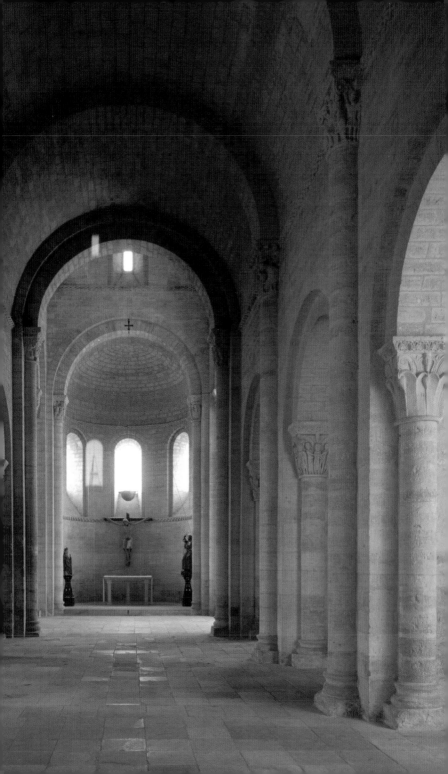

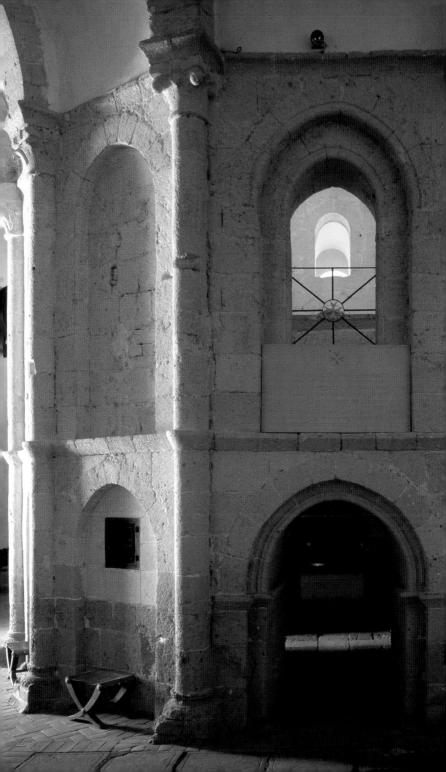

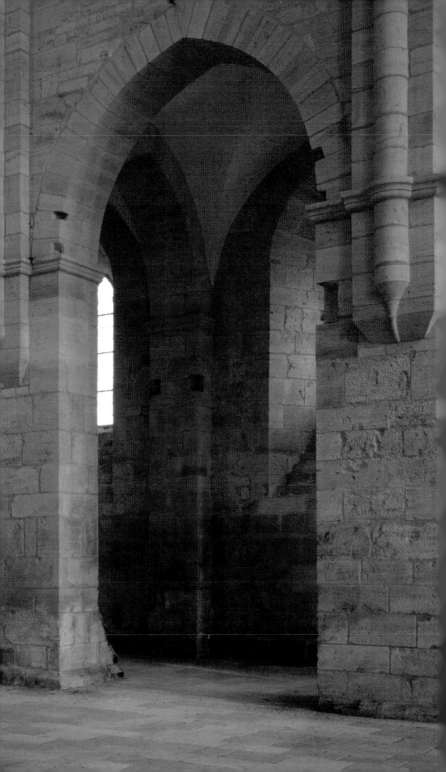

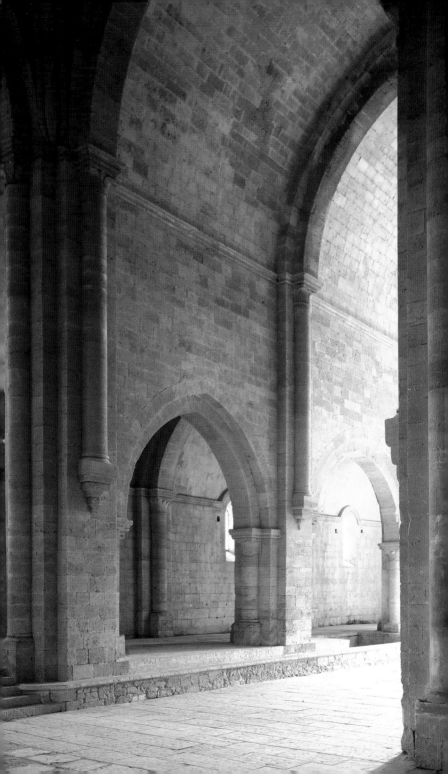

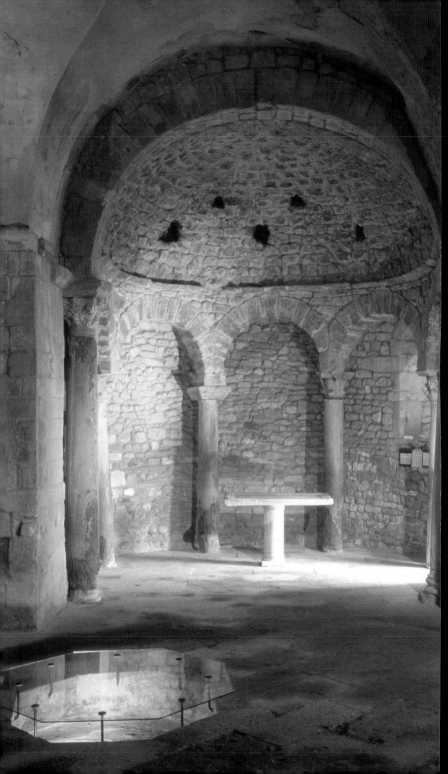

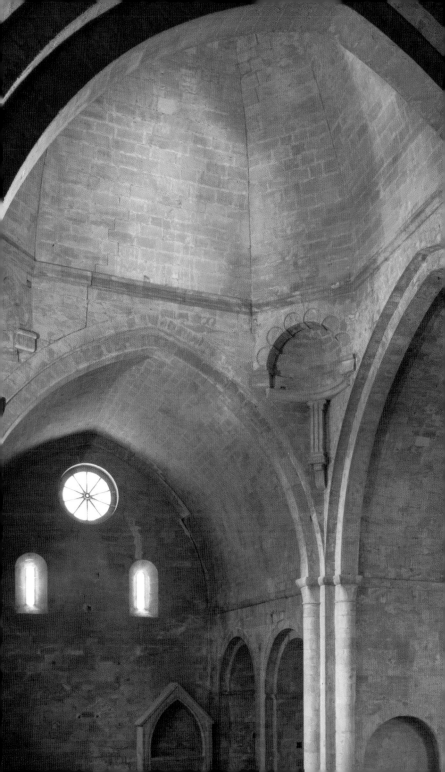

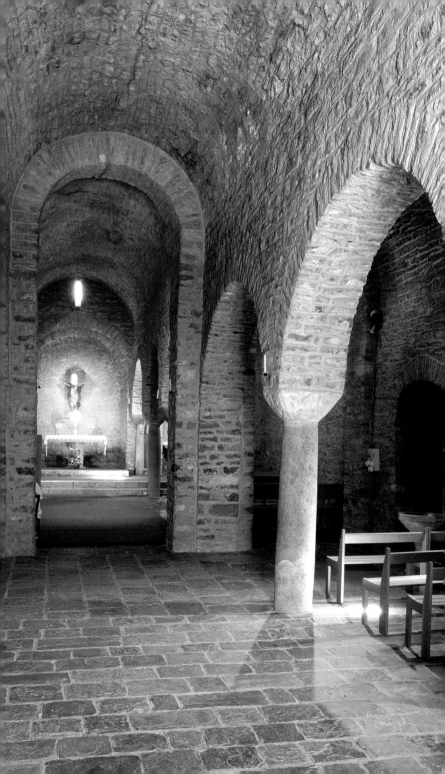

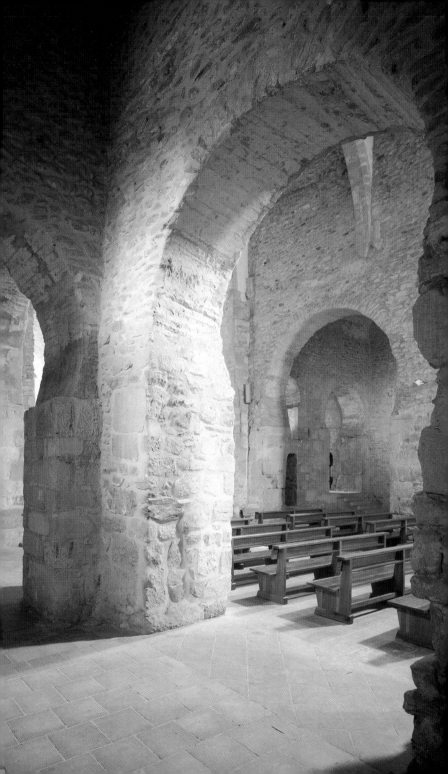

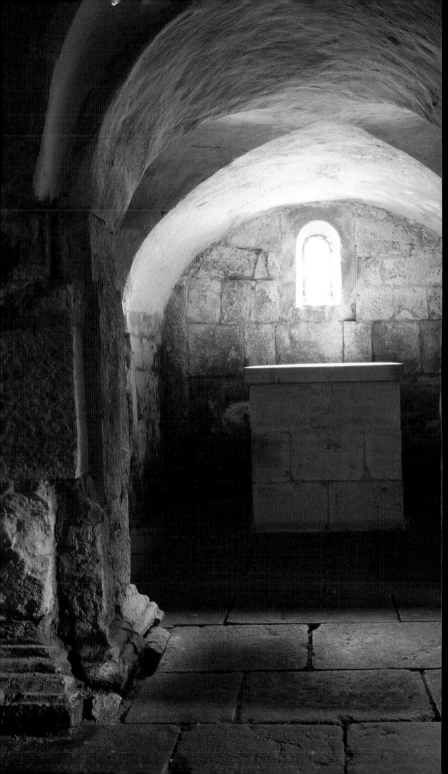

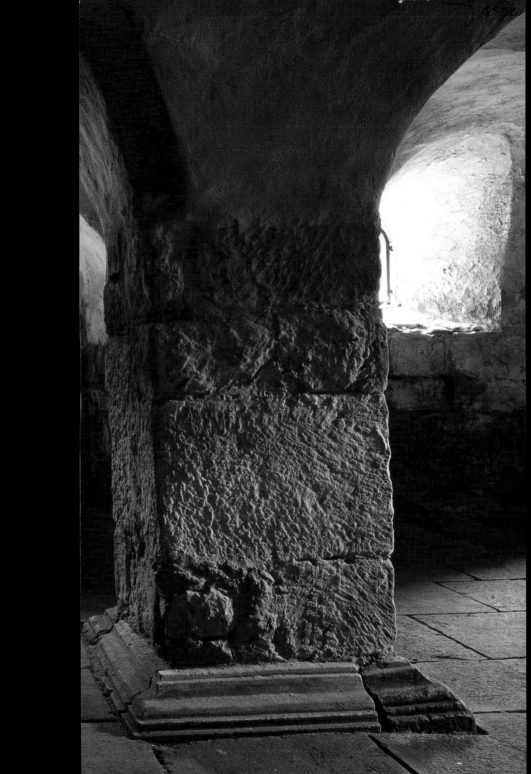

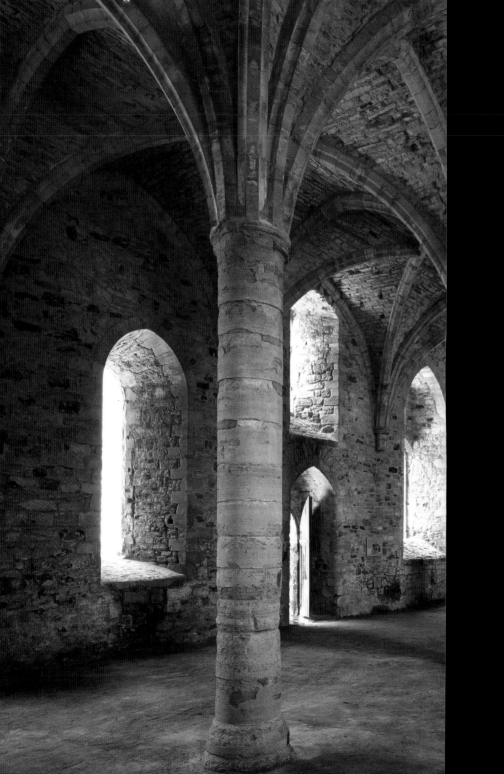

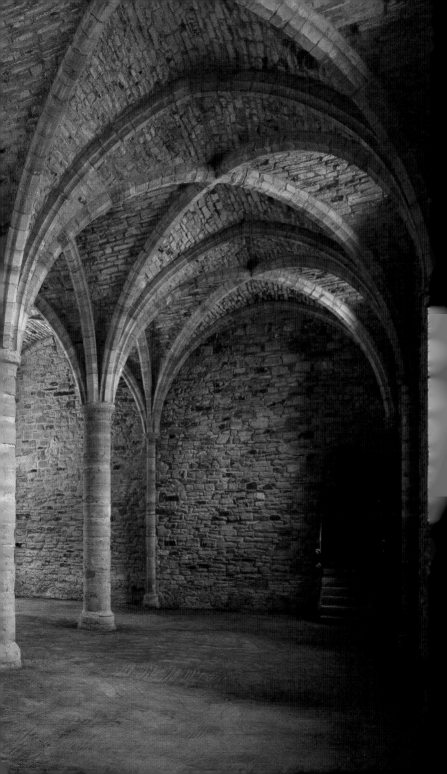

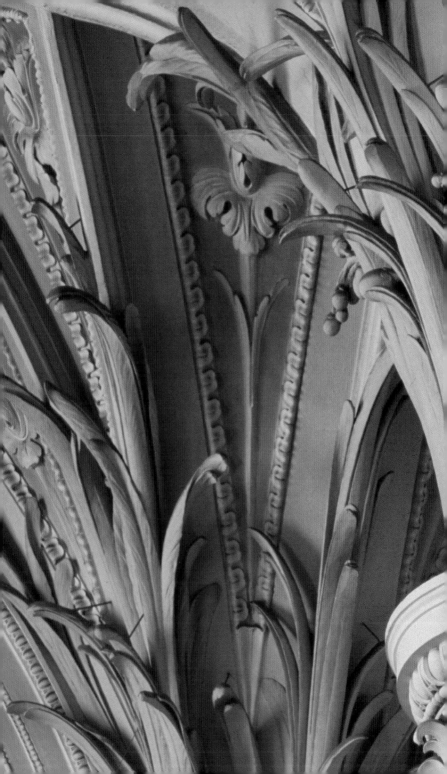

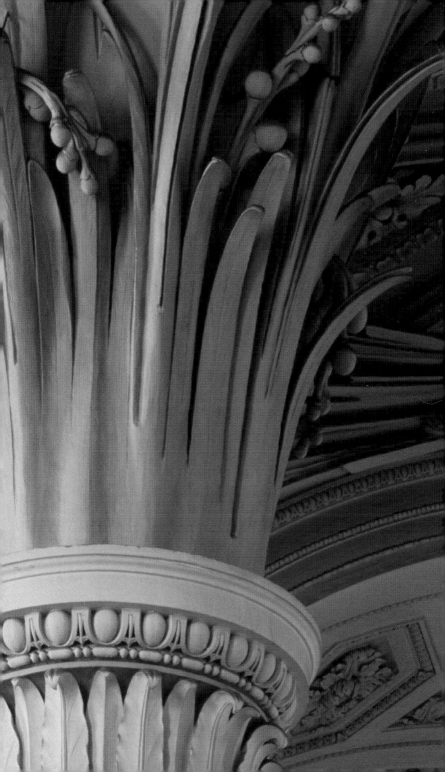

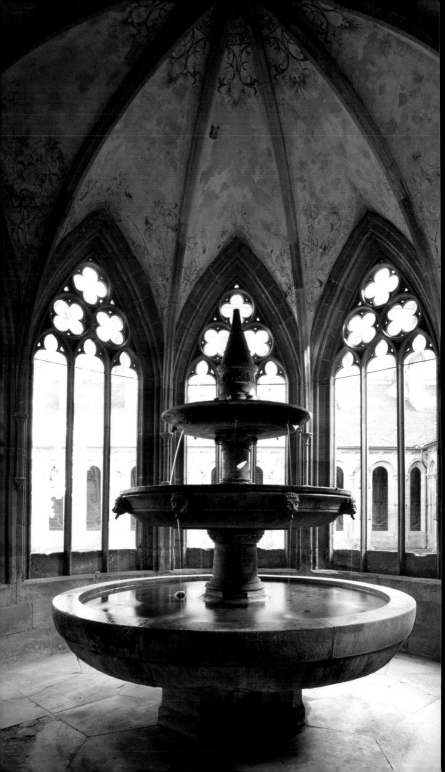

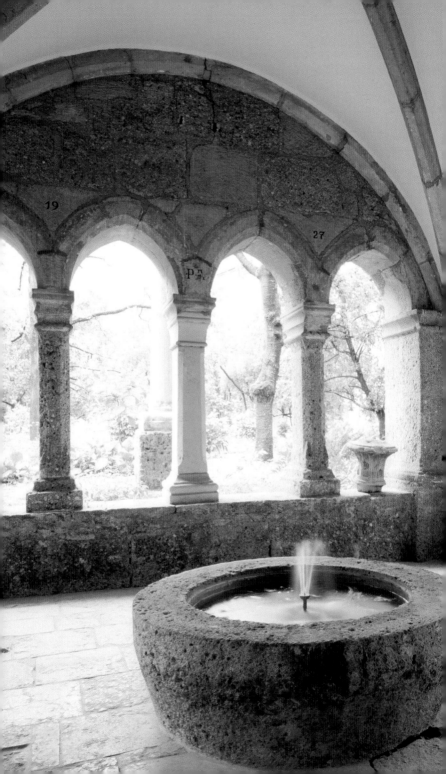

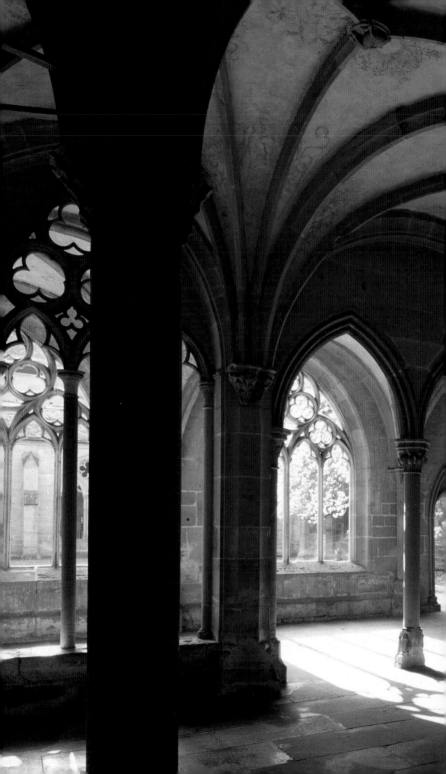

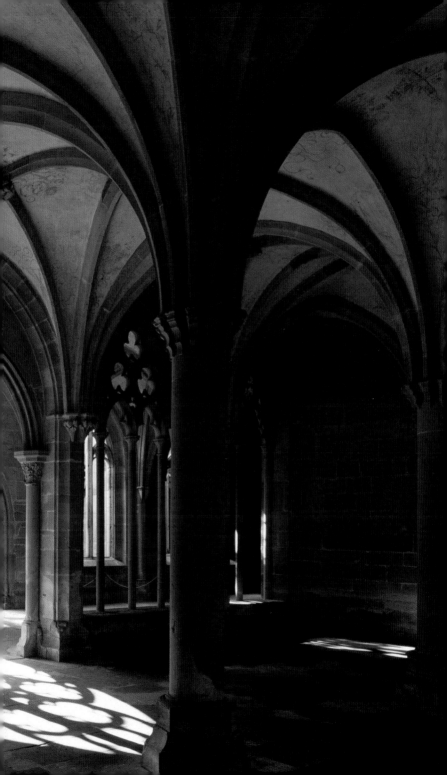

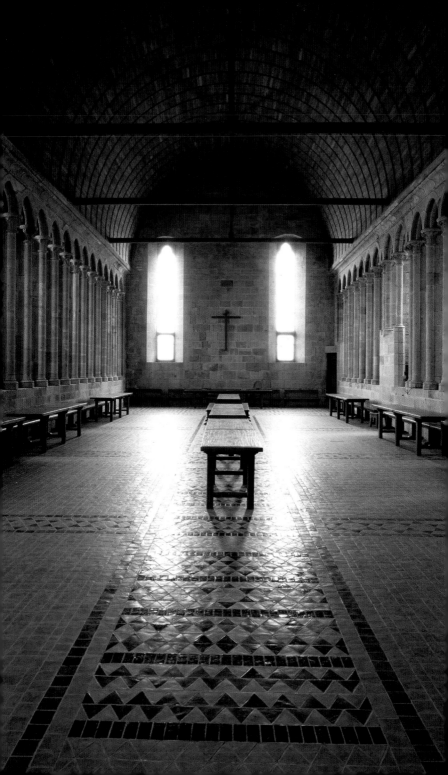

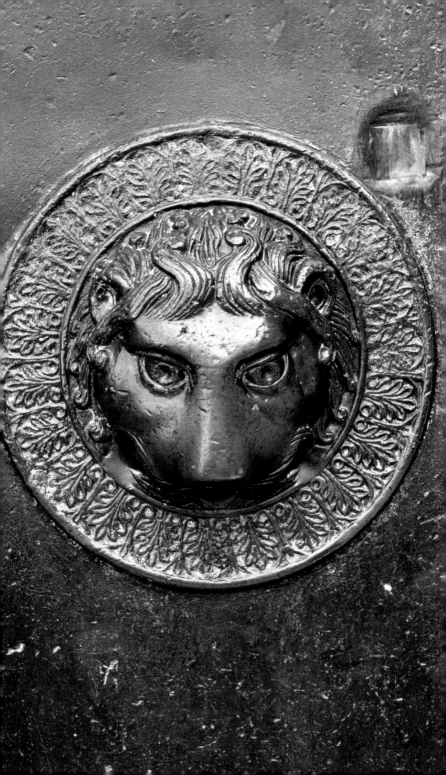

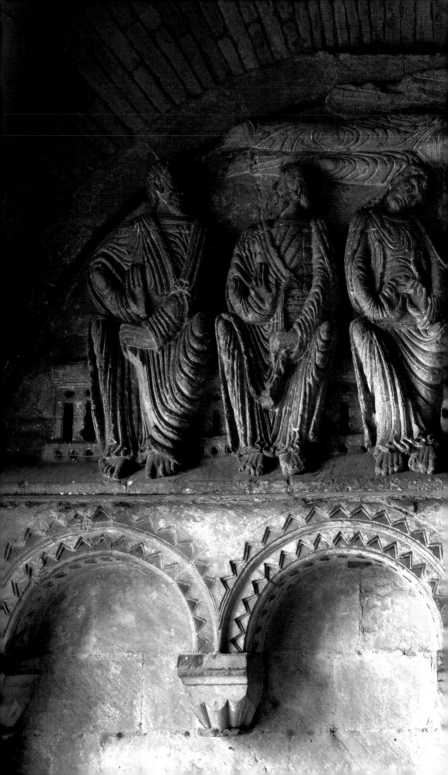

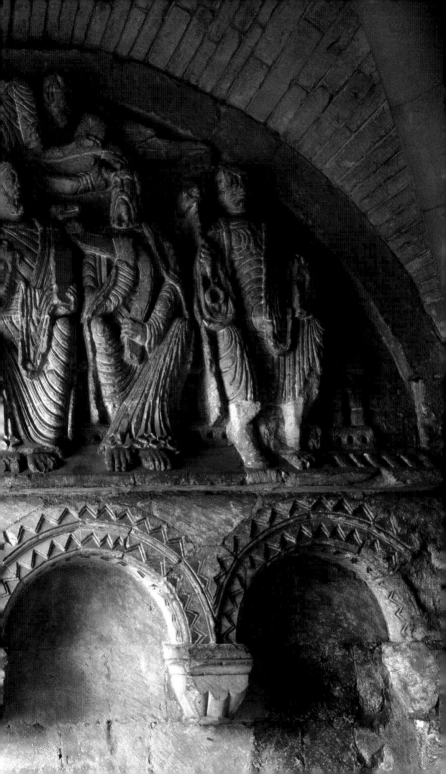

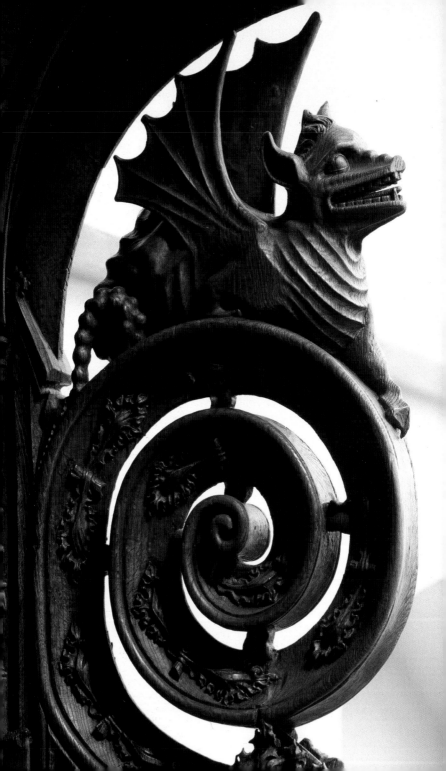

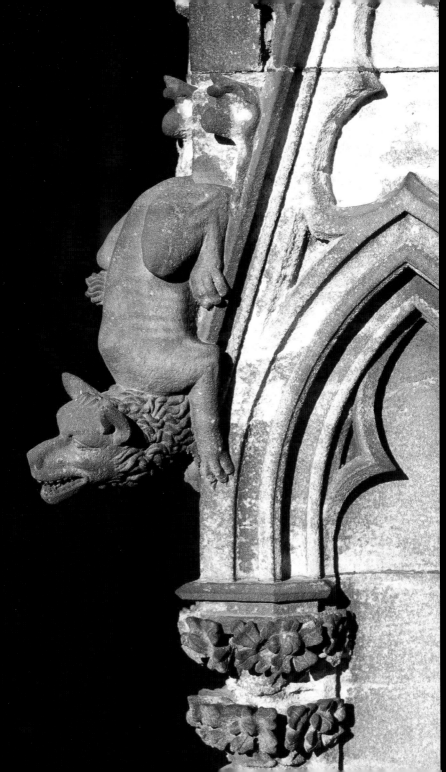

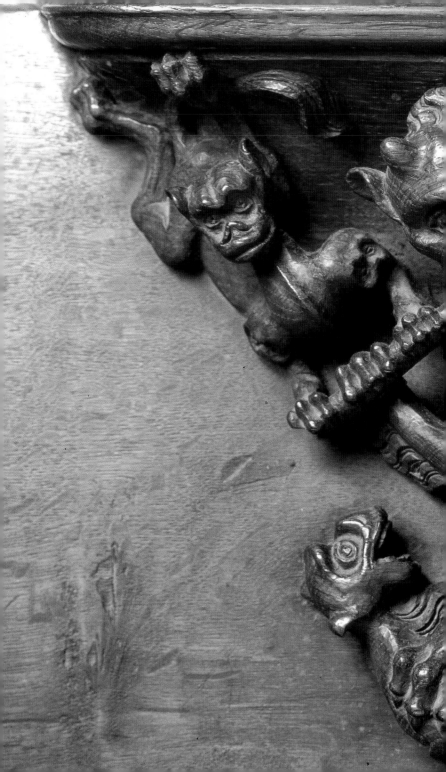

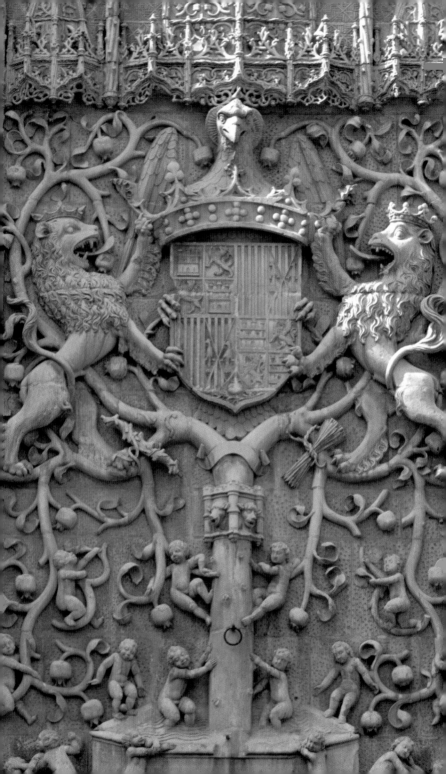

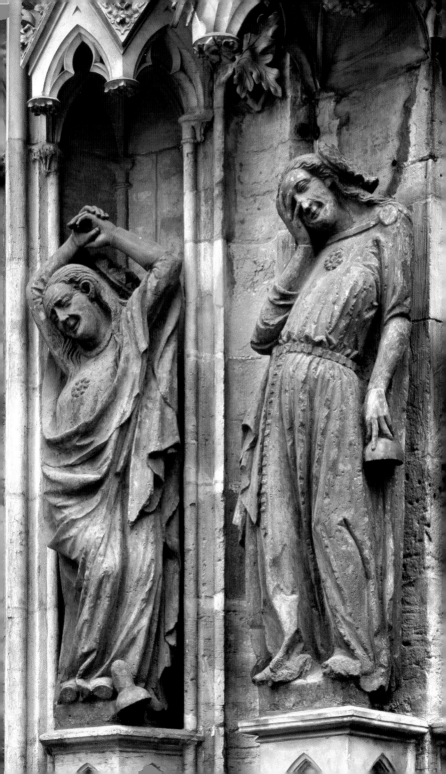

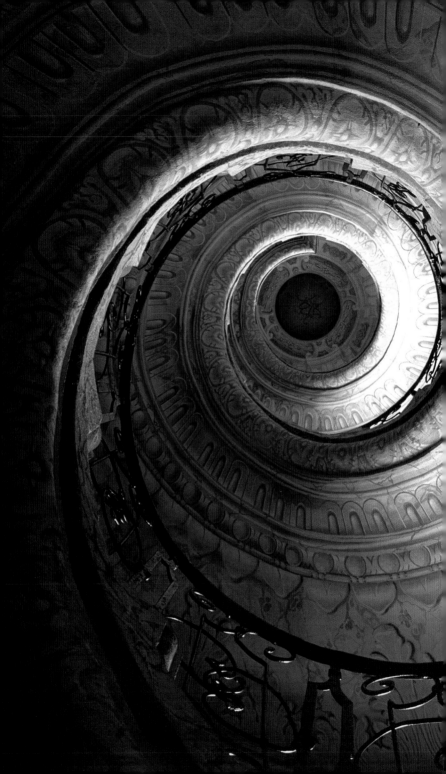

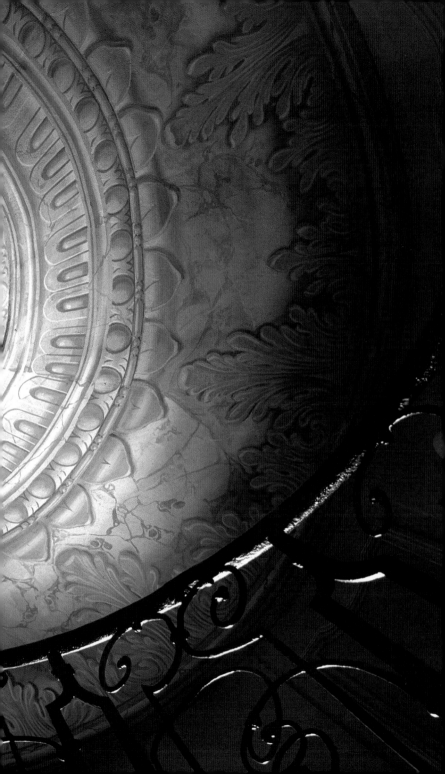

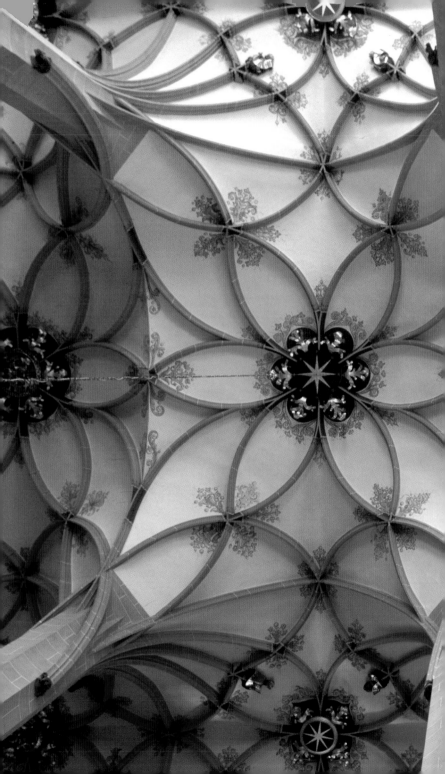

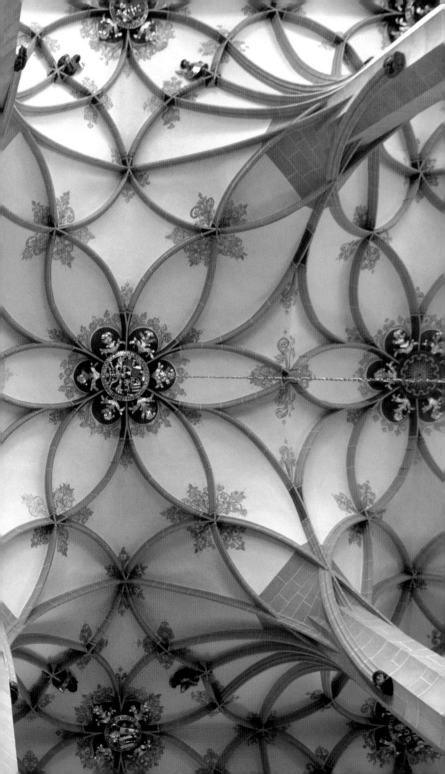

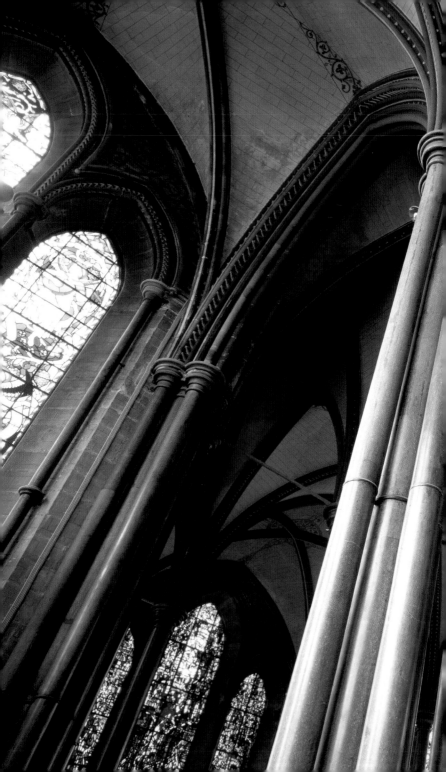

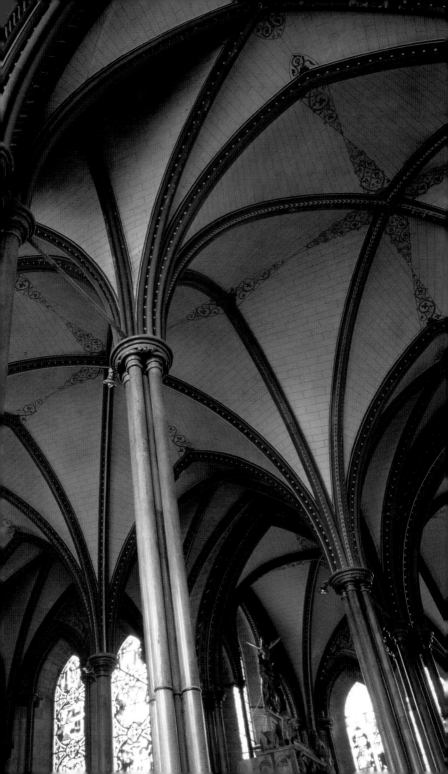

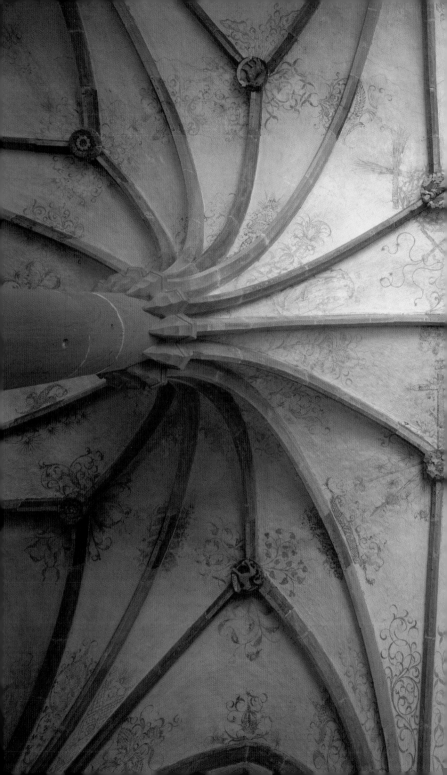

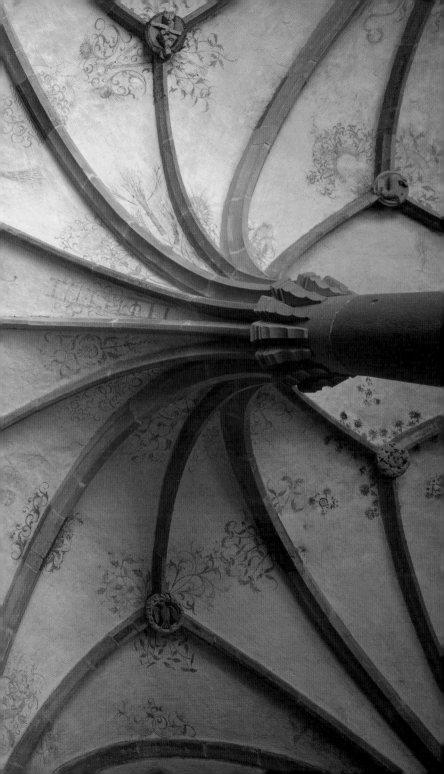

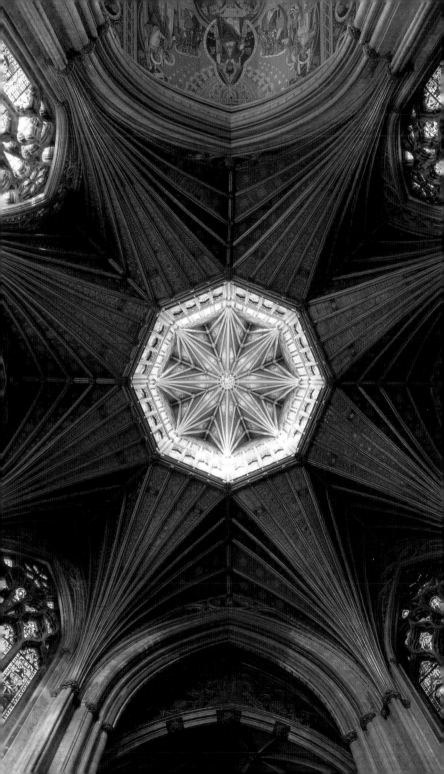

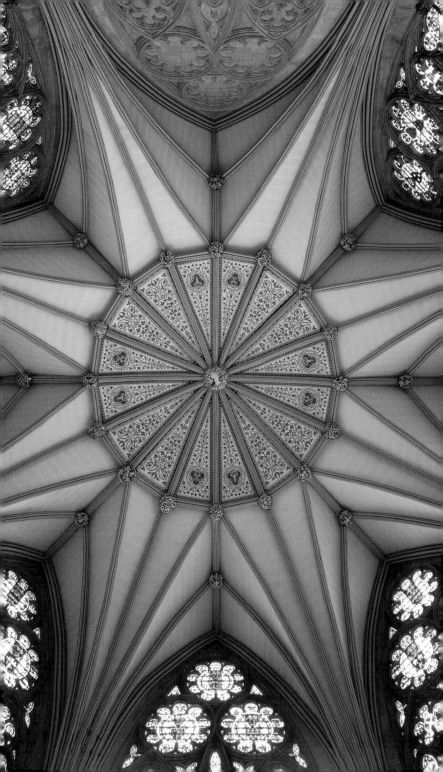

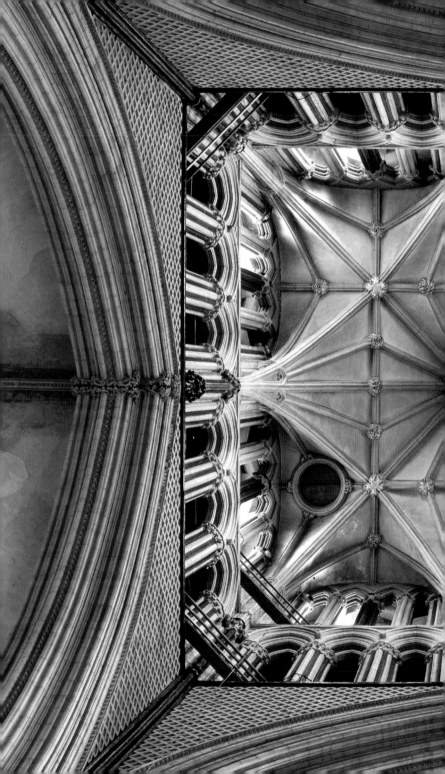

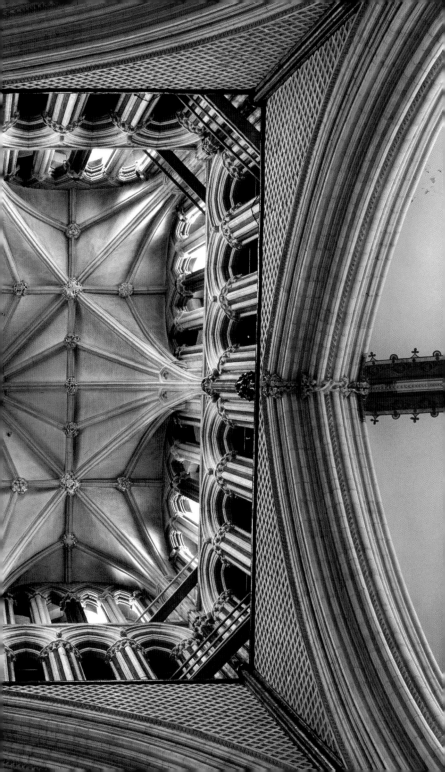

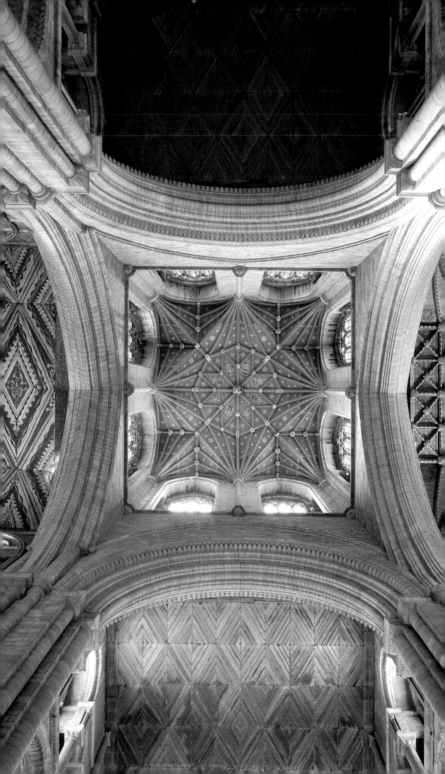

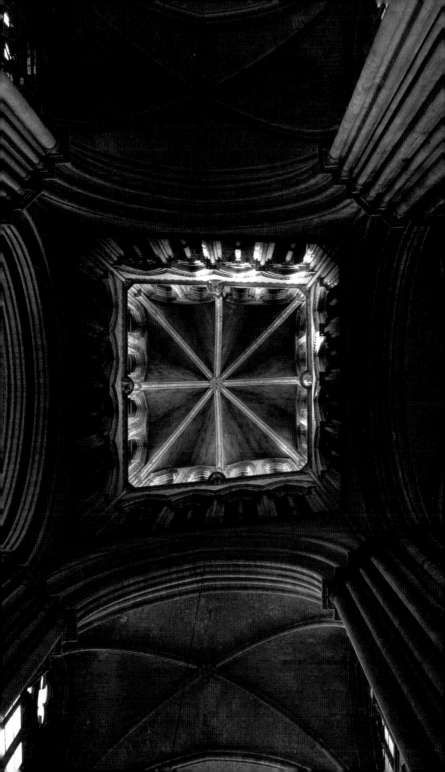

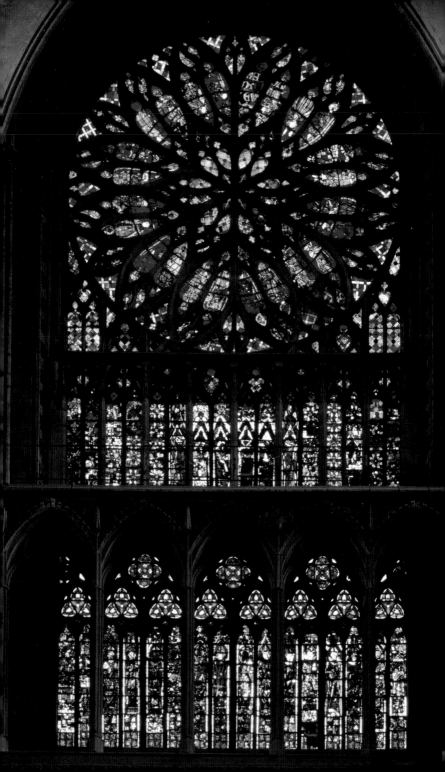

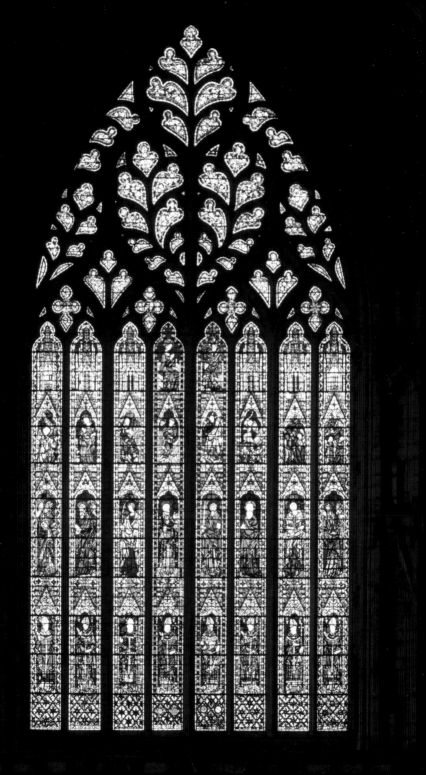

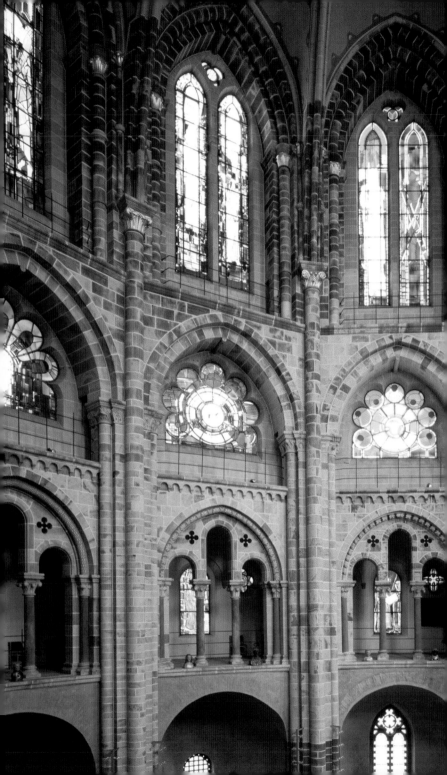

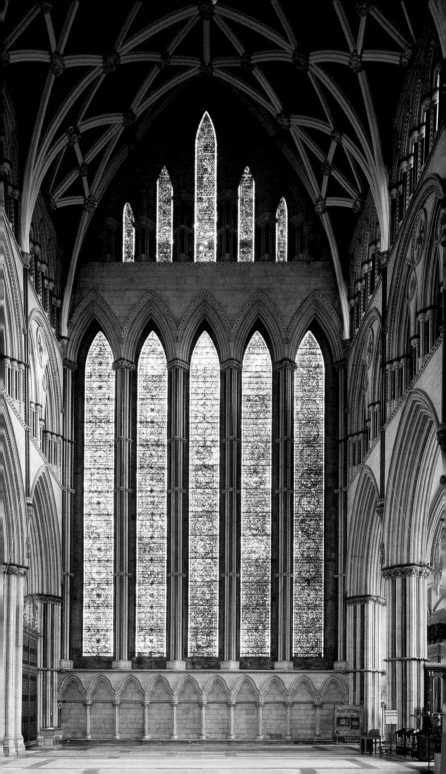

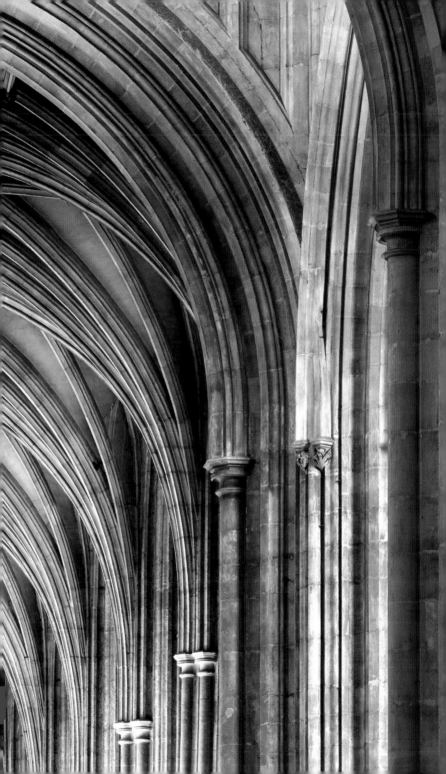

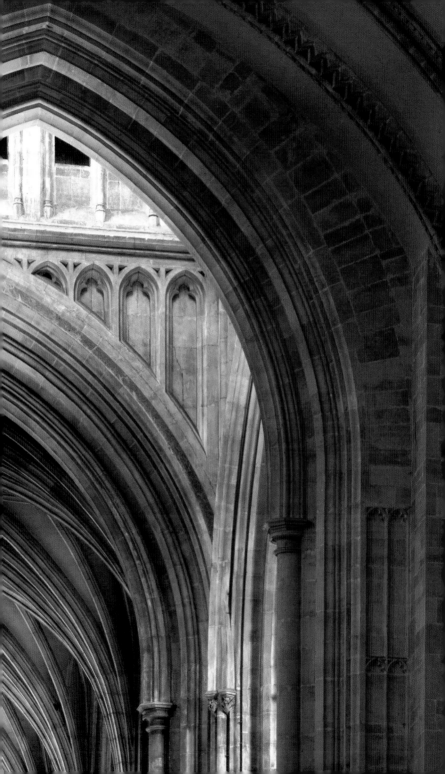

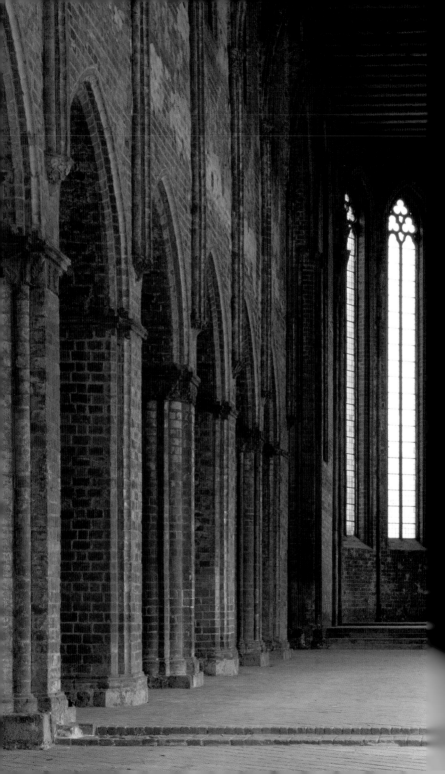

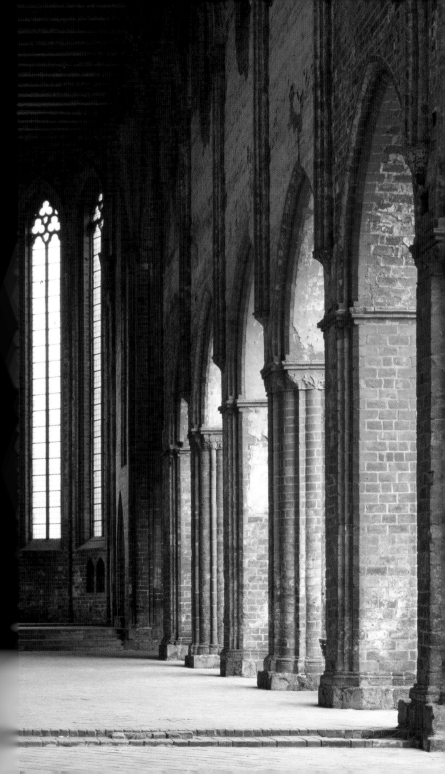

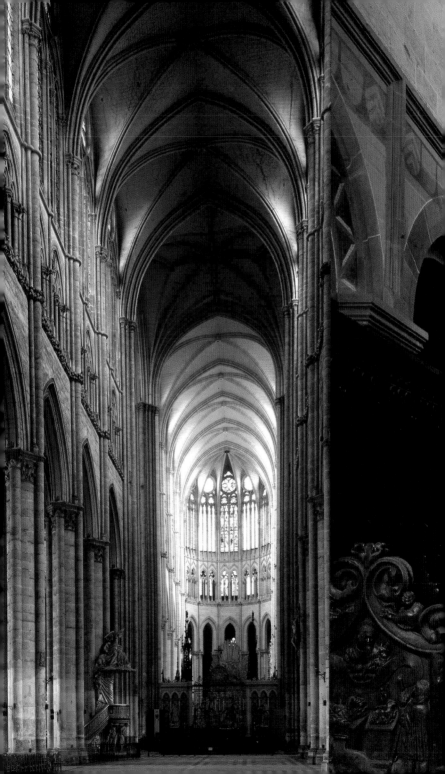

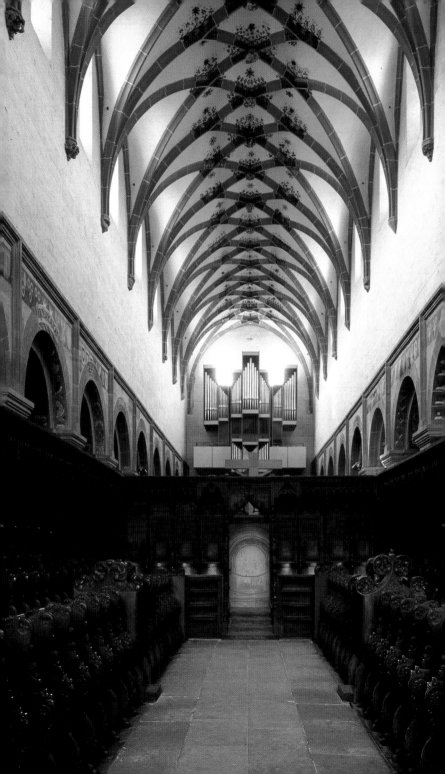

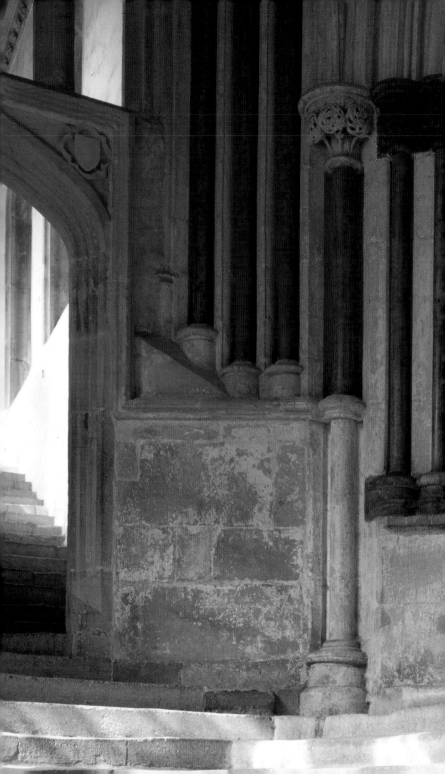

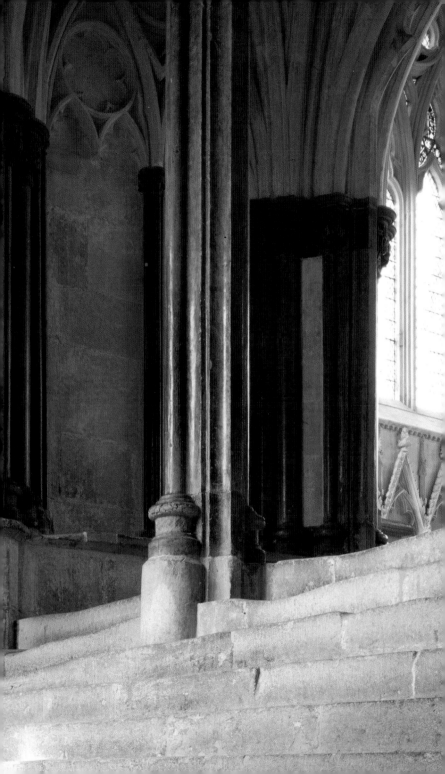

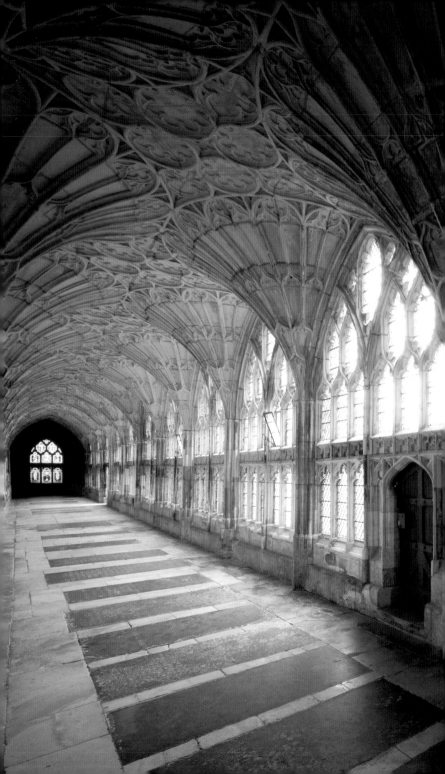

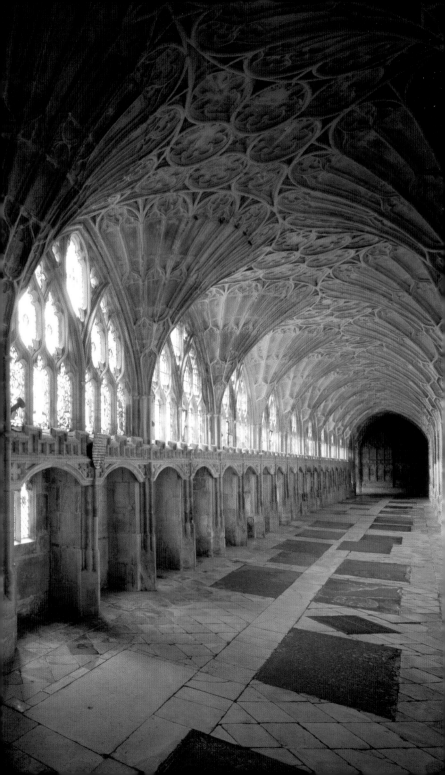

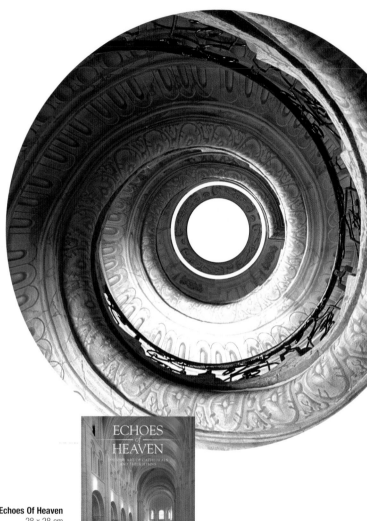

Echoes Of Heaven
28 x 28 cm
96 Photos, 120 pgs.
4 Music CDs
ISBN 3-937406-11-5

Gefällt Ihnen dieses Buch?
Noch mehr Bilder und Musik genießen Sie
im earBOOKS Großformat.

If you liked this book,
you will enjoy the large format earBOOKS
with additional music and pictures.

Si vous avez aimez ce livre, vous l'apprécierez
dans sa version earBOOKS grand format,
avec encore plus de musiques et de photographies.

CD

HEINRICH SCHÜTZ (1585-1672)
Musikalische Exequien op. 7, SWV 279-281 (1636)
[1] I. *Concert in Form einer teutschen Begräbnis-Missa:* 22:56
 "Nacket bin ich von Mutterleibe kommen" SWV 279
 (Soli: 1, 2, 6, 9, 10, 13; Capella: 3, 4, 7, 11, 12, 14; A, C, D, E)

MICHAEL PRAETORIUS (1571-1621)
[2] *Herzlich lieb hab ich dich* 3:27
(Musae Sioniae VIII, 1610) – (2, 5, 8, 9, 10, 12, 15, 16; B, E)

[3] II. *Herr, wenn ich nur dich habe* SWV 280 3:22
 (Chorus I: 2, 6, 9, 13; Chorus II: 1, 7, 10, 14; A, C, D, E)
[4] III. *Canticum B. Simeonis:* 4:38
 "Herr, nun lässest du deinen Diener" – *"Selig sind die Toten"* SWV 281
 (Chorus I: 6, 9, 11, 12, 13; Chorus II: 1, 2, 14; Chorus II duplicatus: 3, 4, 10; A, C, D, E)

MICHAEL PRAETORIUS
[5] *Mit Fried und Freud ich fahr dahin* 0:53
(Musae Sioniae VIII, 1610) – (2, 5, 8, 9, 10, 12, 15, 16; B, E)

[6] *Hört auf mit Weinen und Klagen* 1:13
(Musae Sioniae VIII, 1610) – (2, 5, 8, 9, 10, 12, 15, 16; B, E)

JOHANN HERMANN SCHEIN (1586-1630)
[7] *Threnus* (1617) 4:48
 (1, 2, 6, 9, 10, 13; E)

HEINRICH SCHÜTZ
[8] *Die mit Tränen säen* SWV 378 3:15
 (Geistliche Chormusik 1648, Nr. 10) – (1, 2, 9, 11, 14; A, E)
[9] *Das ist je gewißlich wahr* SWV 388 4:08
 (Geistliche Chormusik 1648, Nr. 20) – (1, 2, 3, 4, 6, 7, 9, 10, 11, 12, 13, 14; A, E)

JOHANNES CHRISTOPH DEMANTIUS (1567-1643)
[10] *Threnodia "Quis dabit oculis"* (1611) 11:06
 Transcription: Norbert Schuster
 (1, 2, 3, 4, 6, 7, 9, 10, 11, 13, 14; A, E)

SCHÜTZ-AKADEMIE
Soprano: Mieke van der Sluis (1), Irena Troupová (2), Stella Arman (3),
Barbara Ullrich (4), Susanne Ryden (5)
Altus: Bernhard Landauer (6), Gerd Reichard (7), Detlef Bratschke (8)
Tenor: Hermann Oswald (9), Manuel Warwitz (10), Johannes Chum (11),
Eric Mentzel (12)
Bass: Reinhard Decker (13), Colin Mason (14), Thomas Herberich (15),
Günther Schmidt (16)
Basso continuo: Niklas Trüstedt, violone (A); Norbert Schuster, violone (B);
Hans-Werner Apel, theorbo (C); Wolfgang Katschner, theorbo (D);
Matthias Wilke, positiv organ (E)

HOWARD ARMAN

Tuning pitch: a = 465 Hz

Ⓟ 1994 edel records GmbH
Co-Produktion: DS-Kultur

PHOTO INDEX

Interior of the abbey church of Lessay
(Normandy), France

Fan vaulting in the retrochoir
at Peterborough Cathedral
(Cambridgeshire), England

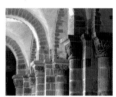

North aisle, Speyer Cathedral,
Germany

Monks' dormitory in the former
Cistercian abbey of Eberbach,
Germany

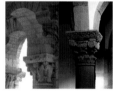

Former convent church of
Saint-André-de-Sorède
(Roussillon), France

Ruins of an abbey at Jumiéges
(Normandy), France

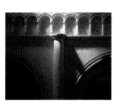

Western Gothic iconostasis in the
church of Santa Cristina de Lena,
Pola de Lena (Asturia), Spain
© Markus Bassler

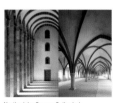

Side aisle of the convent church at
Mont-Saint-Michel (Normandy), France

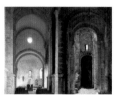

Capital in the narthex of the convent
church at Saint Benoît sur Loire
(Val de Loire), France

Capital in the baptismal chapel, Speyer
Cathedral, Germany

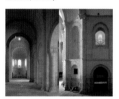

Dais in the former convent church at
Cerisy-la-Forêt (Normandy), France

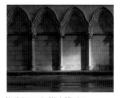

North transept of York Minster
(Yorkshire), England
© Markus Bassler

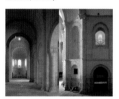

Former convent church of San Martin
at Fromista (Castille), Spain
© Markus Bassler

Vera Cruz templars' church at Segovia
(Castille), Spain, © Markus Bassler

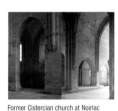

Former Cistercian church at Noirlac
(Val de Loire), France
© Achim Bednorz

Crossing in the former Cistercian church
at Silvacane (Provence), France

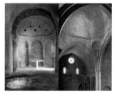

Font in the "baptisterium" at
Venasque (Provence), France

Crossing in the former convent church at
Senanque (Provence), France

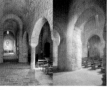

Upper church of the convent complex
of Saint-Martin-de Canigou
(Roussillon), France

Interior of the abbey church at
Saint-Michel-de Cuxa (Roussillon), France

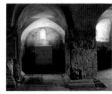

Carolingian crypt in the village church at
Rohr (Thuringia), Germany

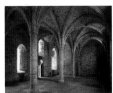

Novices' hall at Battle Abbey
(East Sussex), England

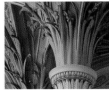

Detail of a column in the church of
St. Nicholas, Leipzig, Germany

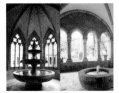

Pump room of the cloisters at
the Cistercian convent of Maulbronn,
Germany

Fountain at St. Peter's abbey,
Salzburg, Austria

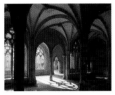

Chapter house and cloisters of
the Cistercian convent at Maulbronn,
Germany

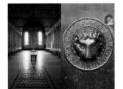

Refectory at Mont-Saint-Michel
(Normandy), France

Detail of the Carolingian bronze door
of Aachen Cathedral, Germany
© Barbara Opitz

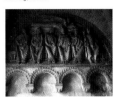

Tympanum at the south door
to Malmesbury Abbey (Wiltshire), England

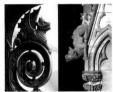

Choir stalls at the Martinikerk,
Bolsward (Friesland), Netherlands
© Barbara Opitz

Gargoyle on the south face of Cologne
Cathedral, Germany

Misericord with demon on a
choir stall in Cologne Cathedral,
Germany

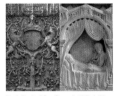

South front of San Gregorio, Valladolid
(Castille), Spain, © Barbara Opitz

Sarcophagus in the abbey church of
Sainte-Trinité in Fécamp
(Normandy), France

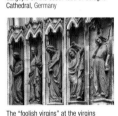

The "foolish virgins" at the virgins
portal of Erfurt Cathedral,
(Thuringia) Germany

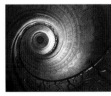

Staircase in the north tower of
the seminary at Melk on the Danube,
Austria

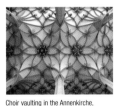

Choir vaulting in the Annenkirche,
Annaberg (Saxony), Germany

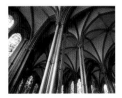

Vaulting in the chapel to St Mary in
Salisbury Cathedral (Wiltshire), England

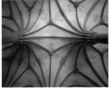

Chapter house in the Cistercian convent
at Maulbronn (Baden-Wuerttemberg),
Germany

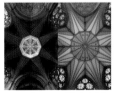

View into the crossing of Ely Cathedral
(Cambridgeshire), England

Vaulting in the chapter house of
York Minster (Yorkshire), England

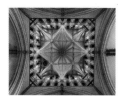

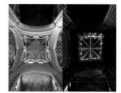

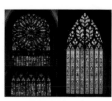

View into the transept tower of
Lincoln Cathedral,
(Lincolnshire) England

View into the transept tower at
Peterborough Cathedral
(Cambridgeshire), England

View into the transept tower of Rouen
Cathedral (Normandy), France

South rose window at Amiens Cathedral
(Picardie), France

"The heart of Yorkshire" in York Minster
(Yorkshire), England

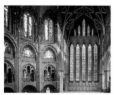

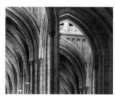

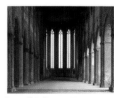

Window by Georg Meistermann in
the decagon of St. Gereon in Cologne,
Germany

"Five Sisters" in York Minster
(Yorkshire), England

Crossing in Canterbury Cathedral
(Kent), England

Former Cistercian convent,
Chorin (Brandenburg), Germany
© Monheim/von Götz

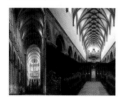

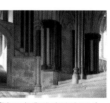

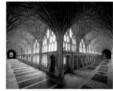

Interior of Amiens Cathedral
(Picardie), France

Choir stalls at the convent church
in Maulbronn
(Baden-Wurttemberg), Germany

Staircase leading to chapter house of
Wells Cathedral (Somerset), England

Cloisters of Gloucester Cathedral
(Gloucestershire), England